WEIRDEVER BOOK

by Patrick B. Humphreys

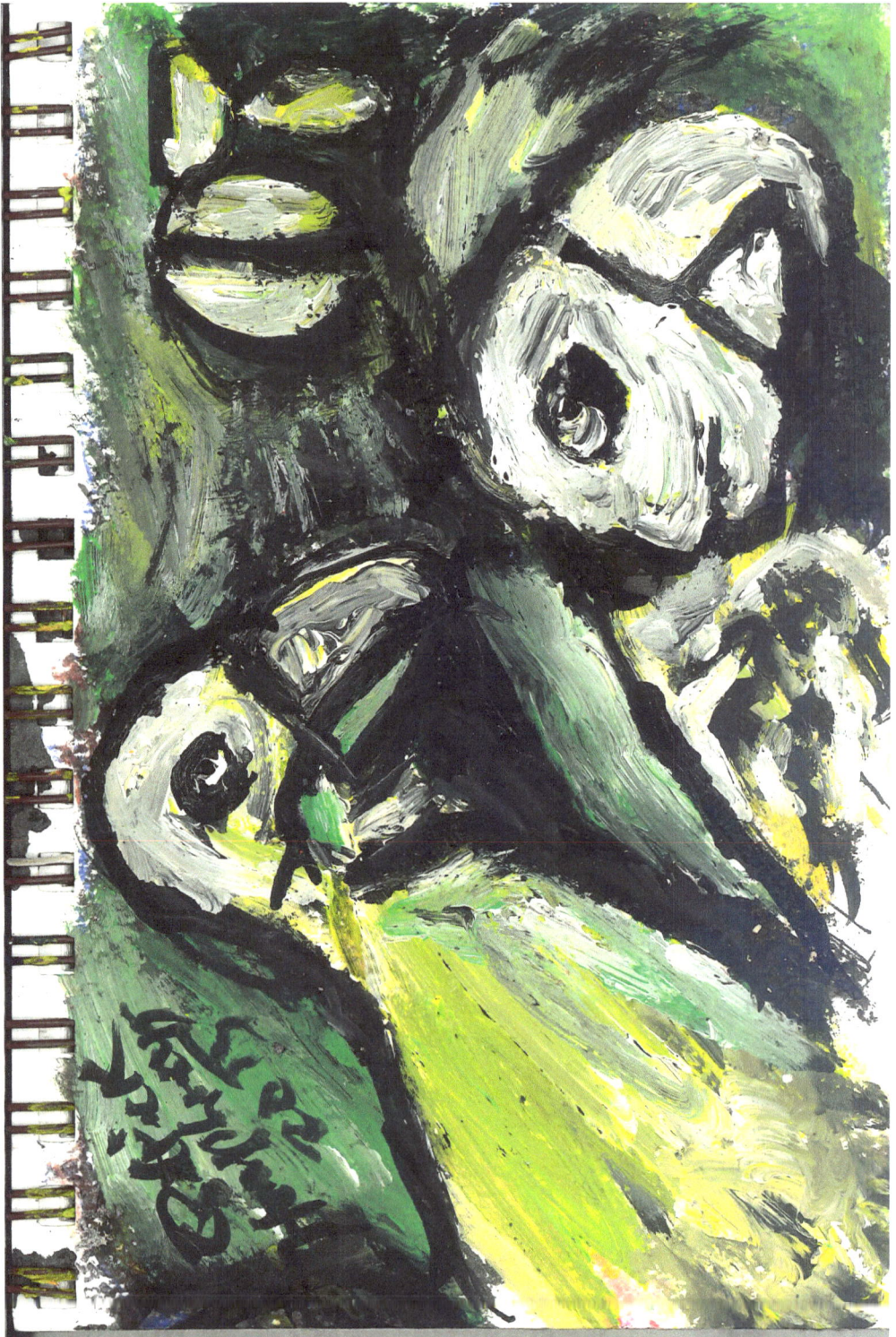

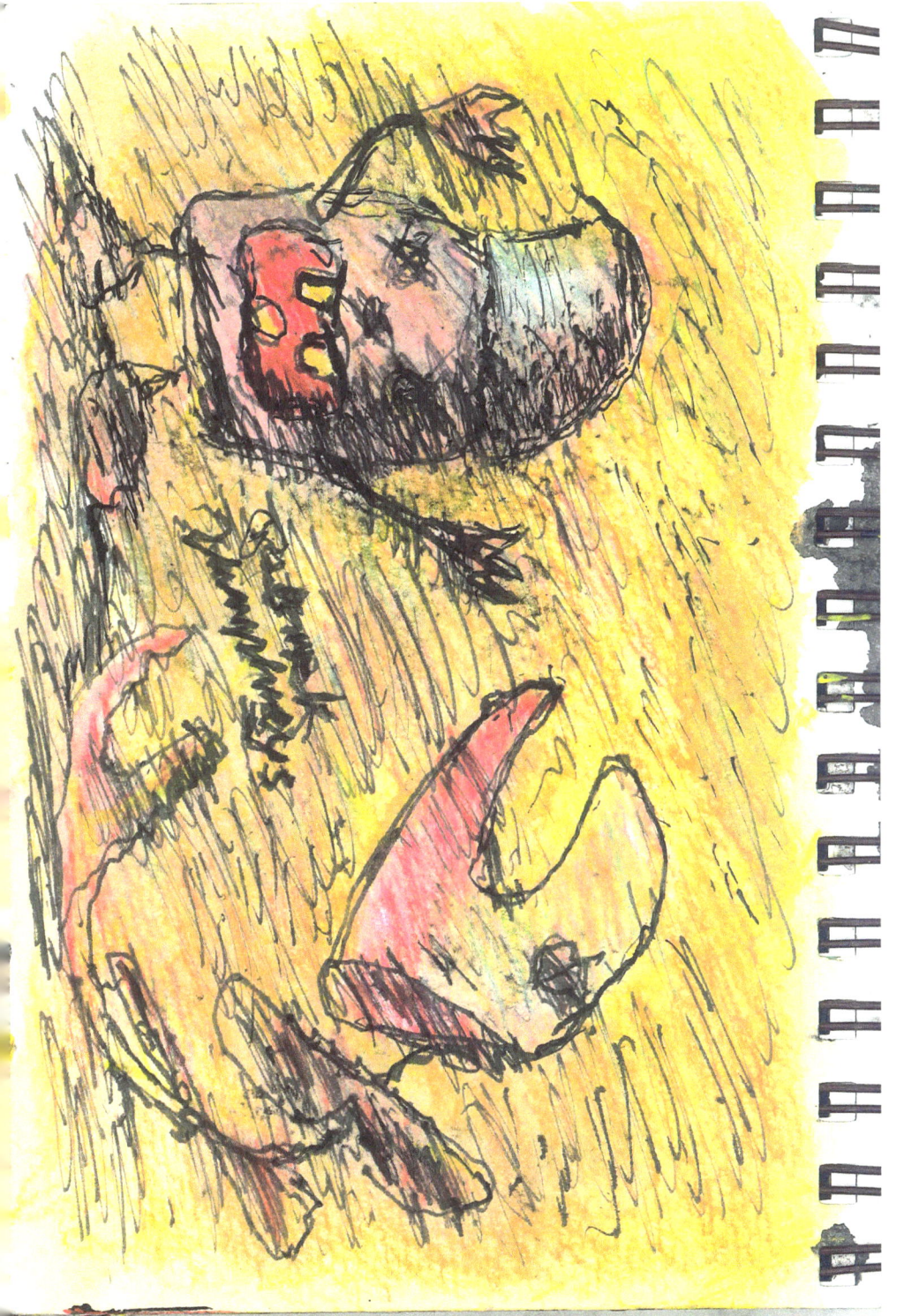

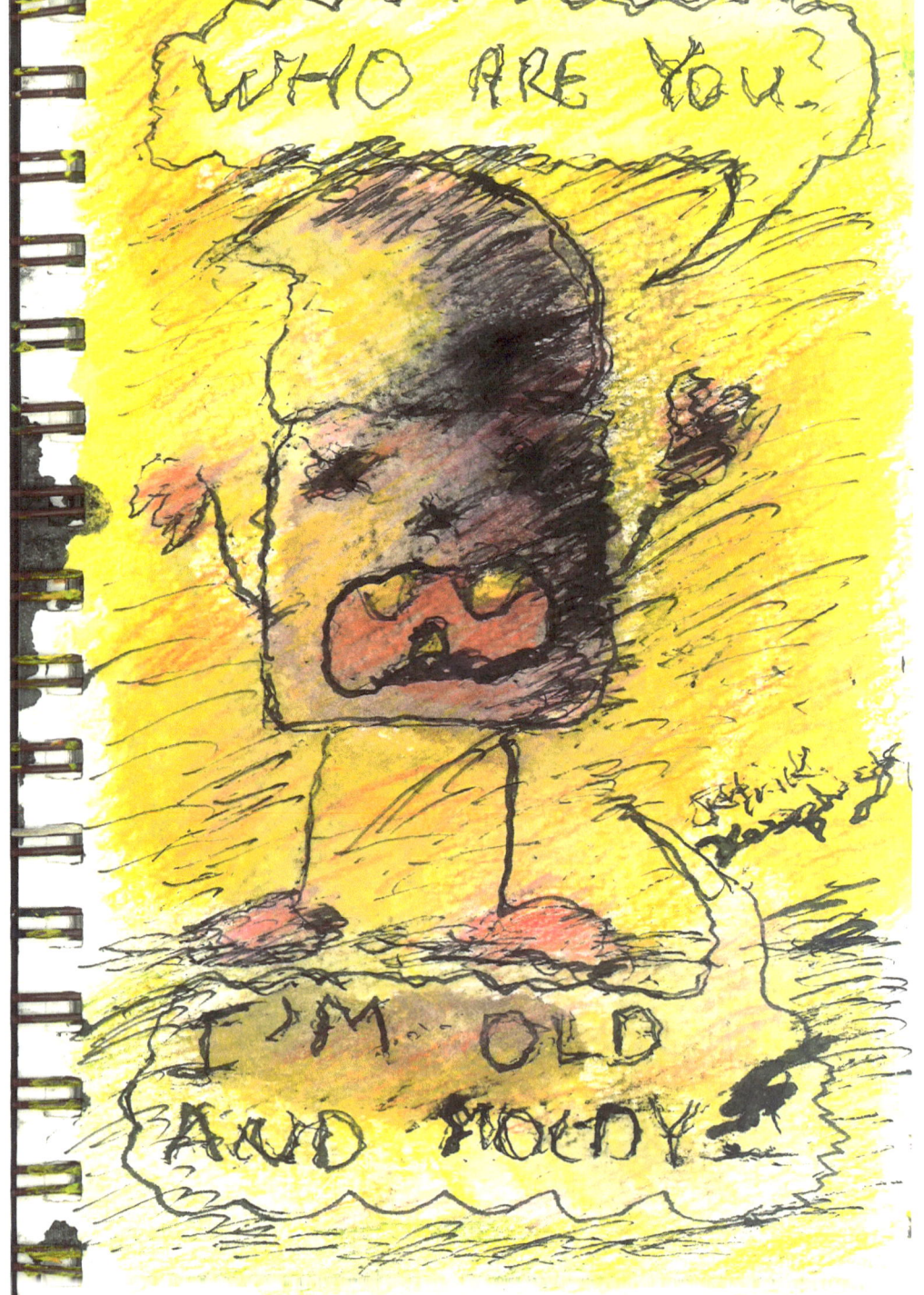

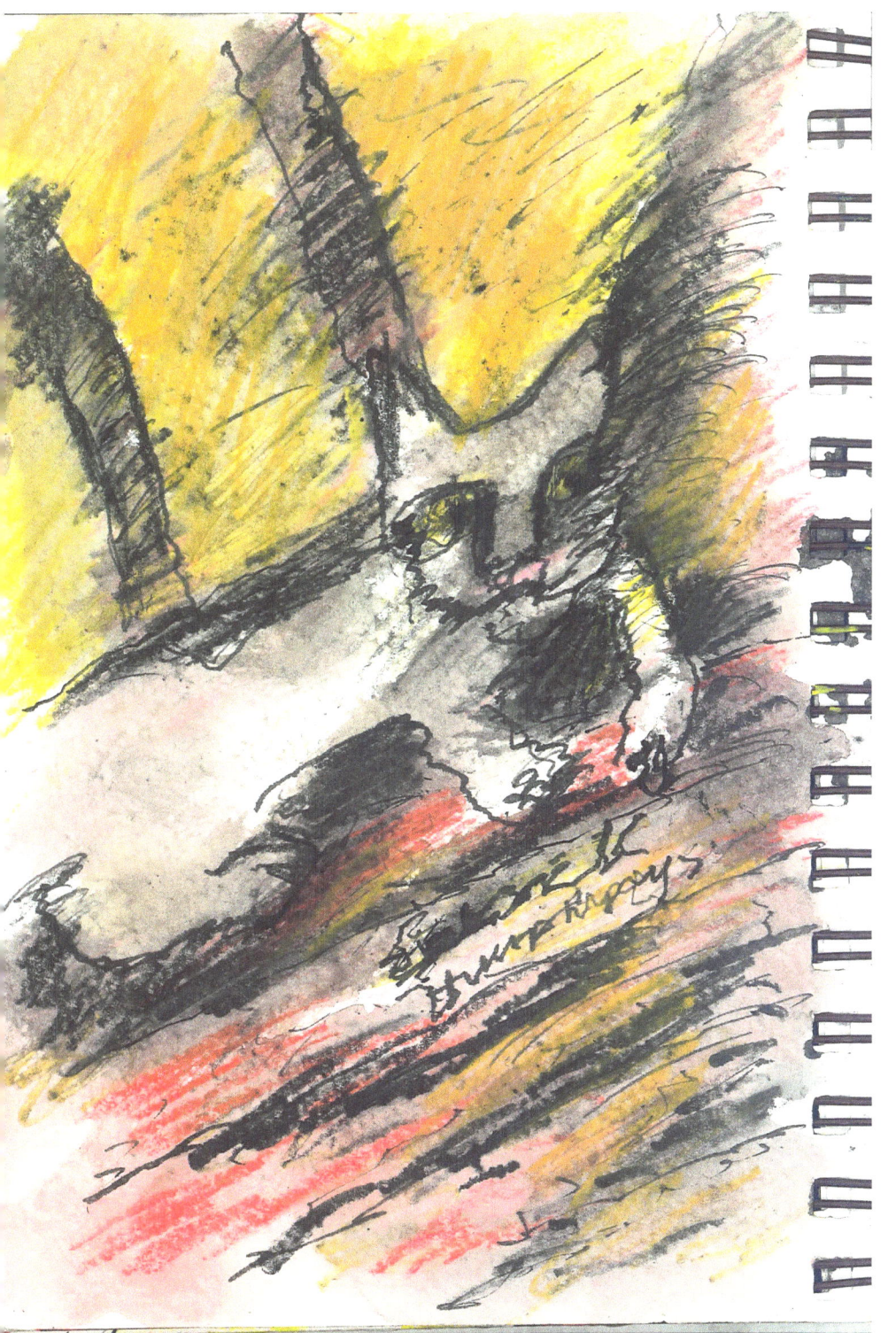

This book is dedicated to my son, Cameron

This book is dedicated to my son Cameron

Two Dancin' Kitties

Three kitties with baby carriage

3

Five Kitties Behind the Window

5

Mommy Cat with Five Kittens equals Six

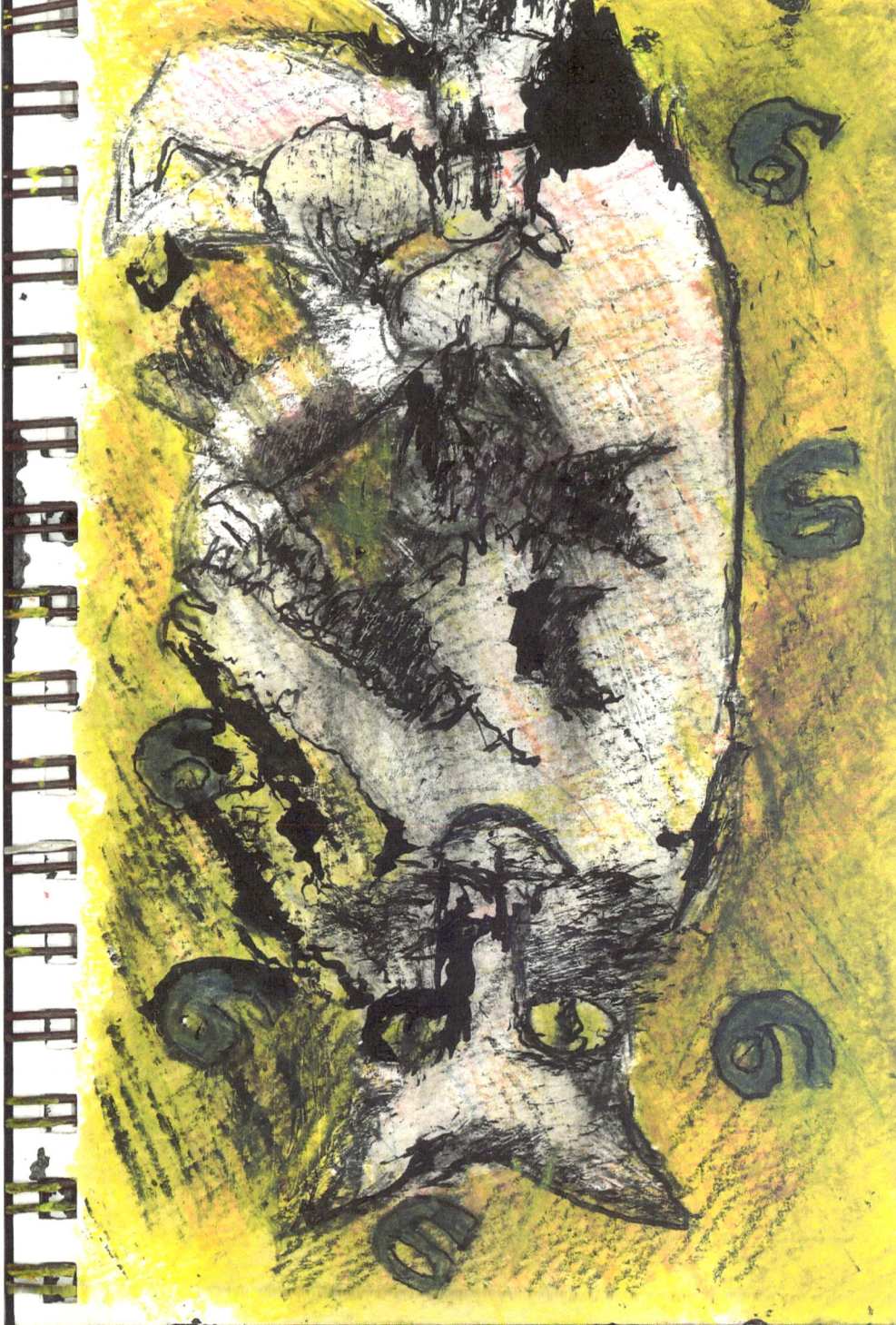

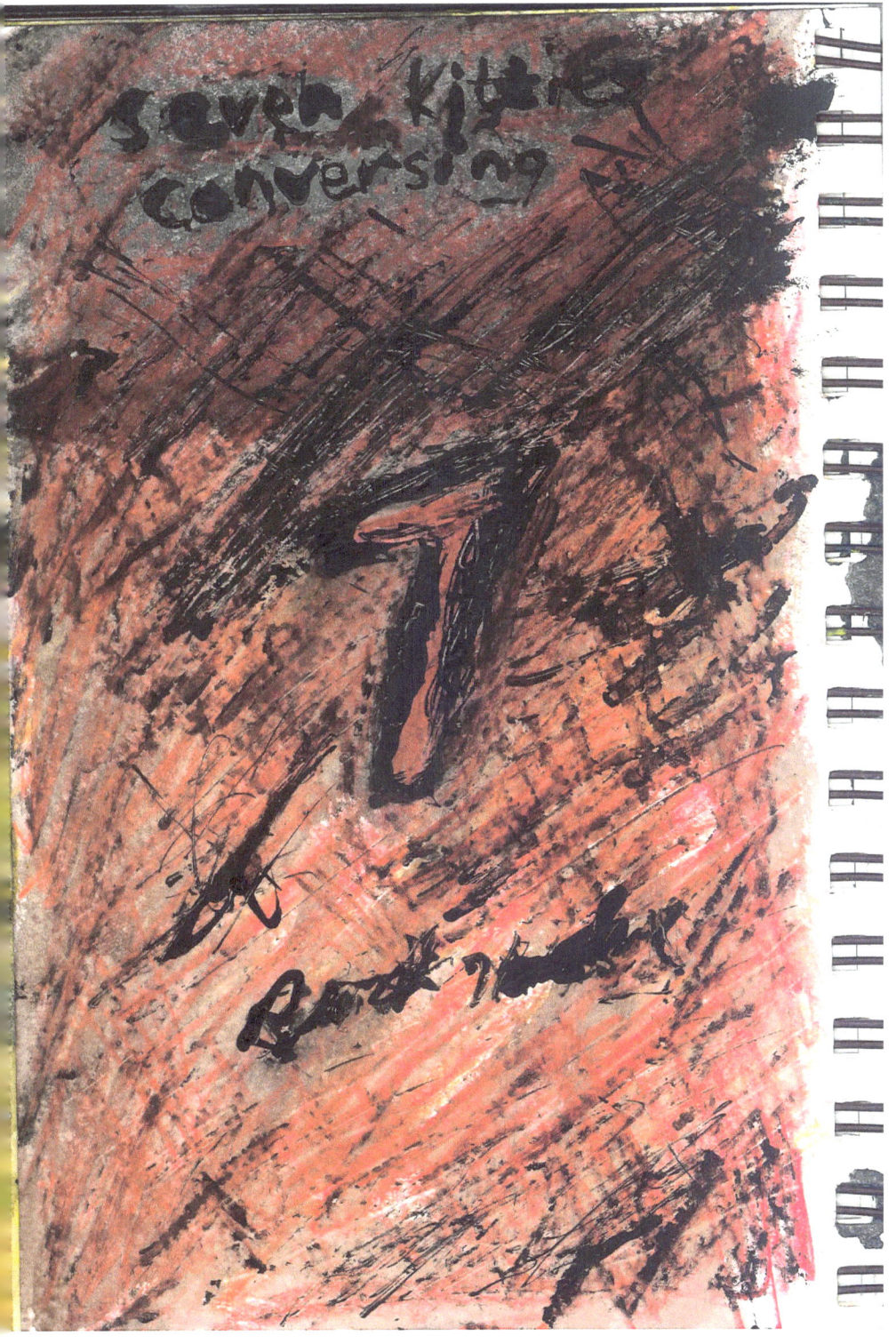

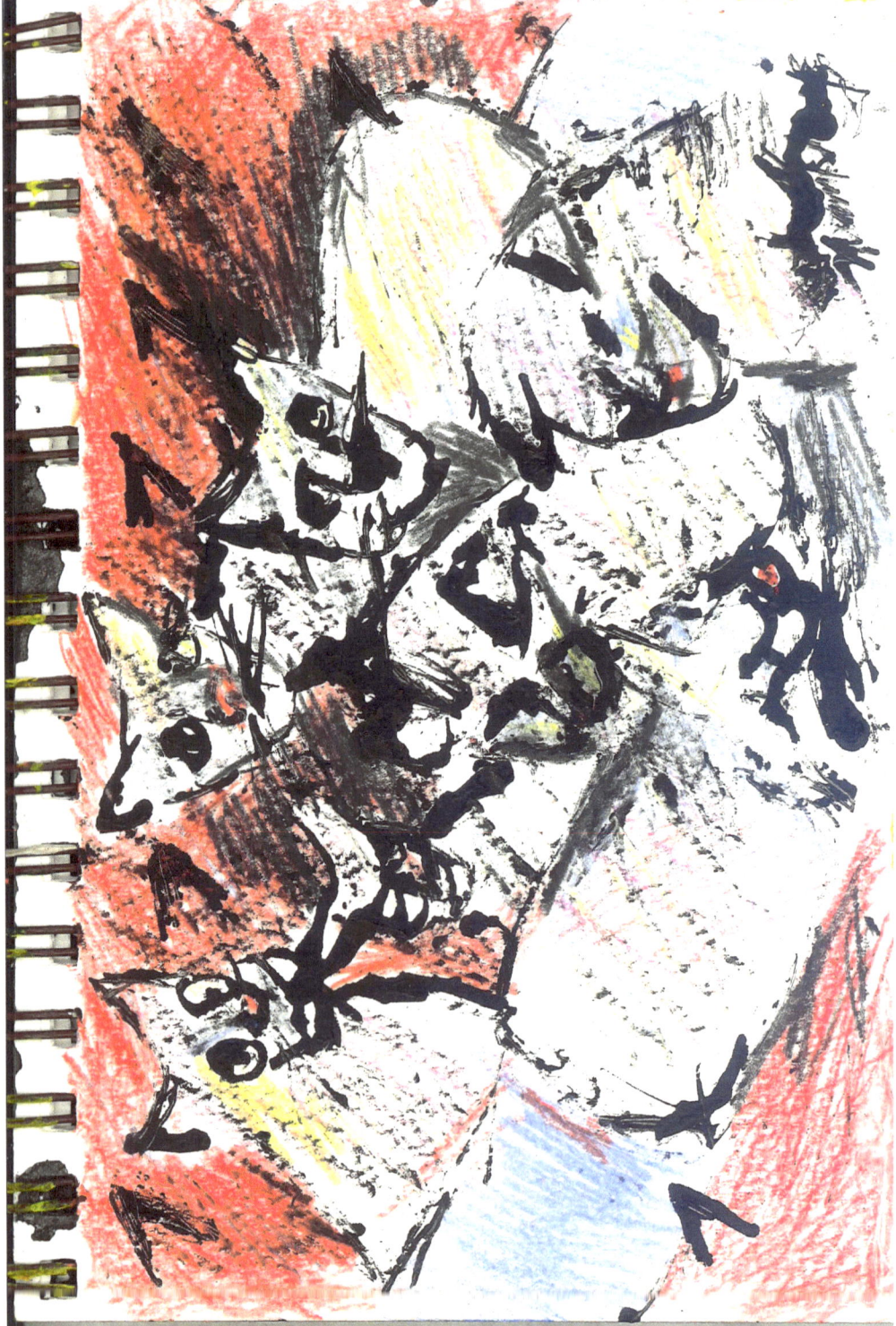

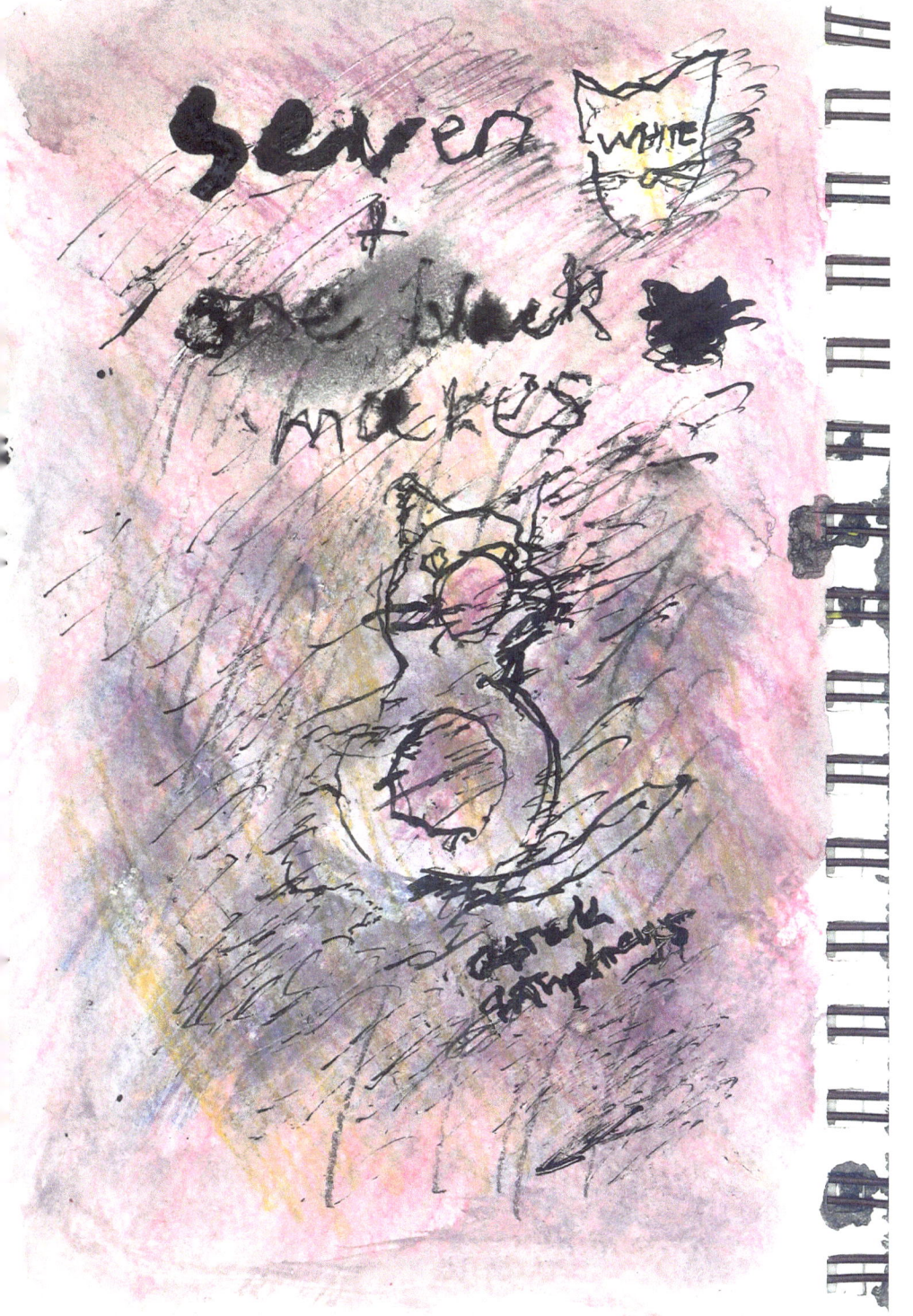

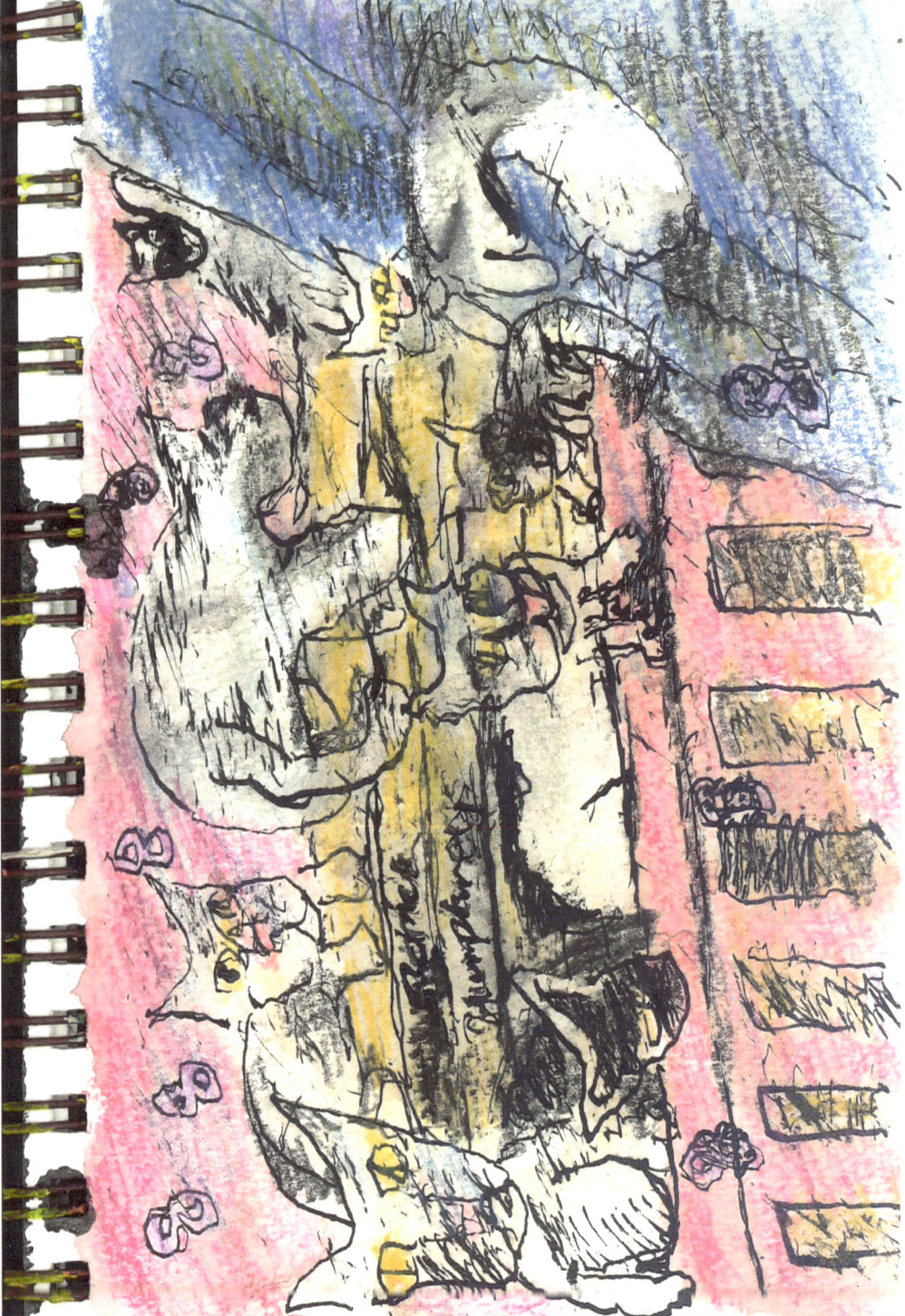

nine kitties by the stars

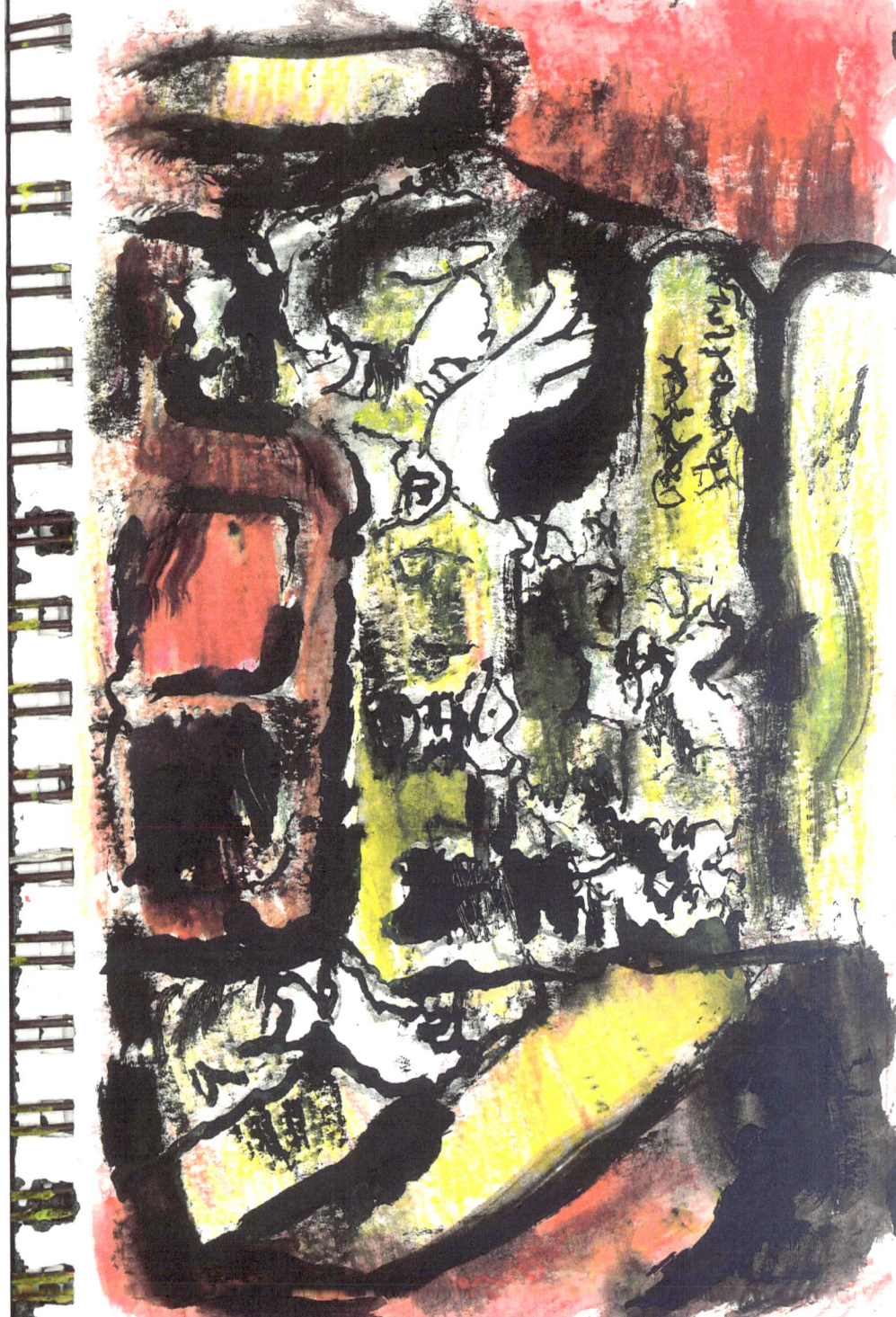

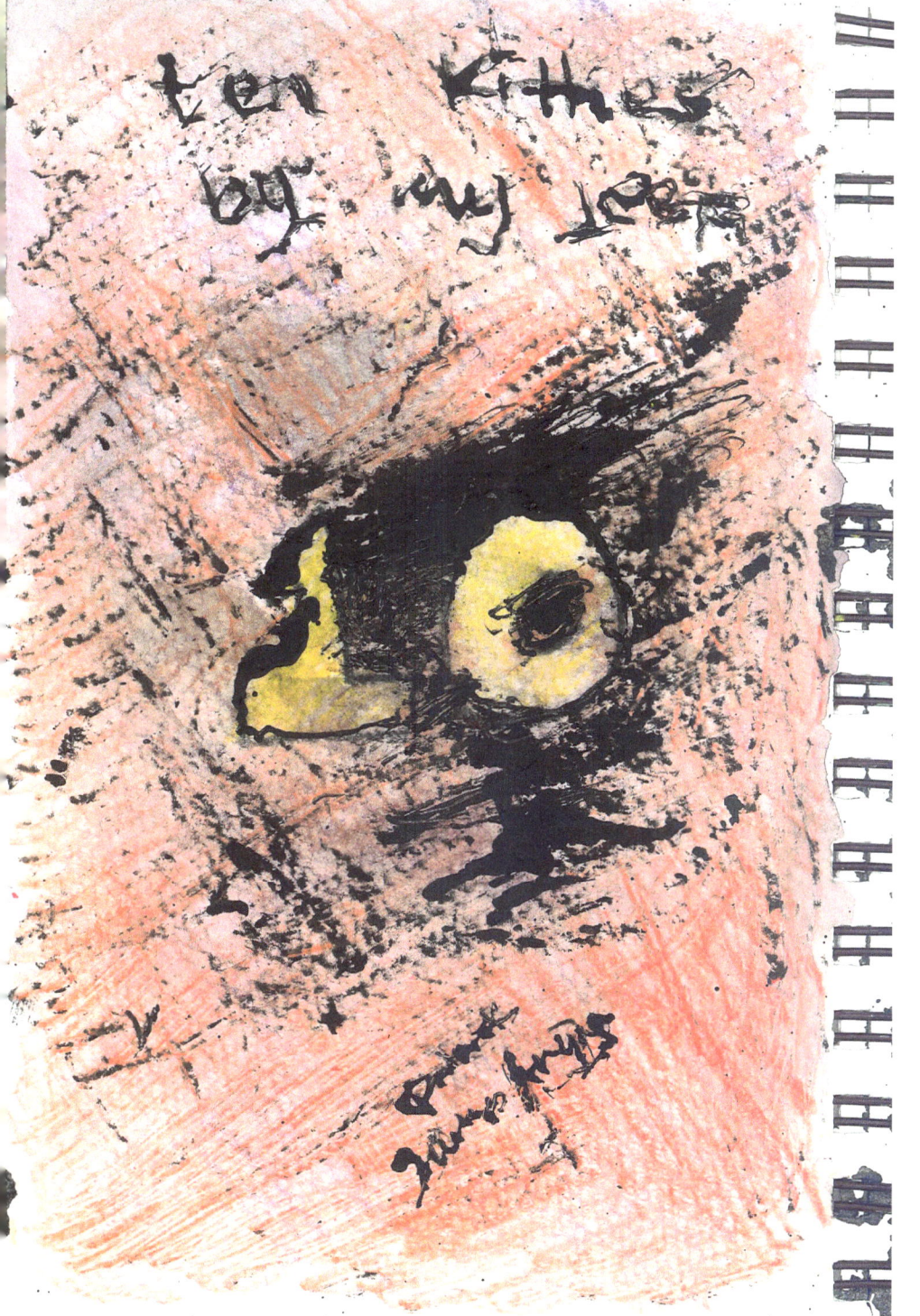

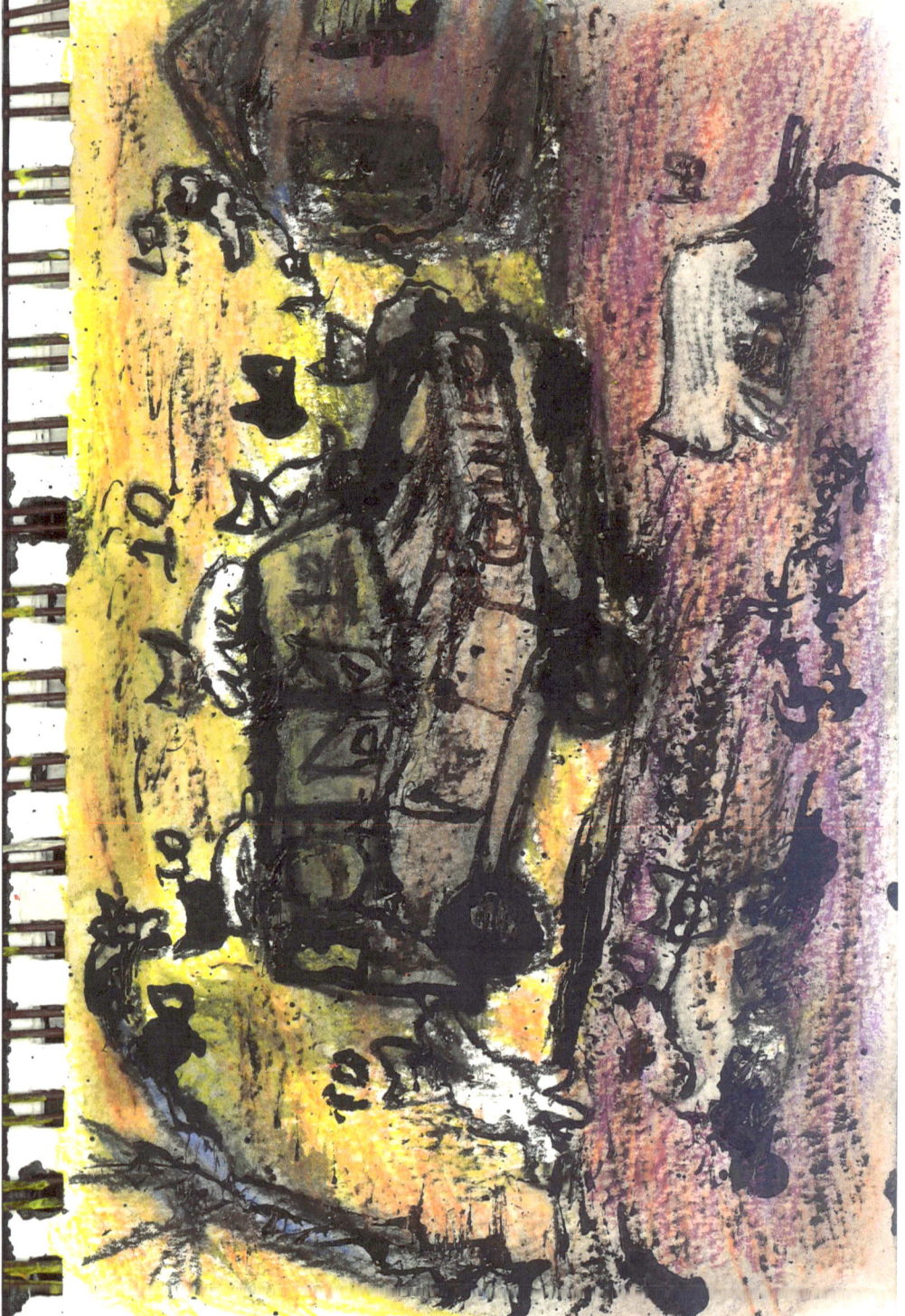

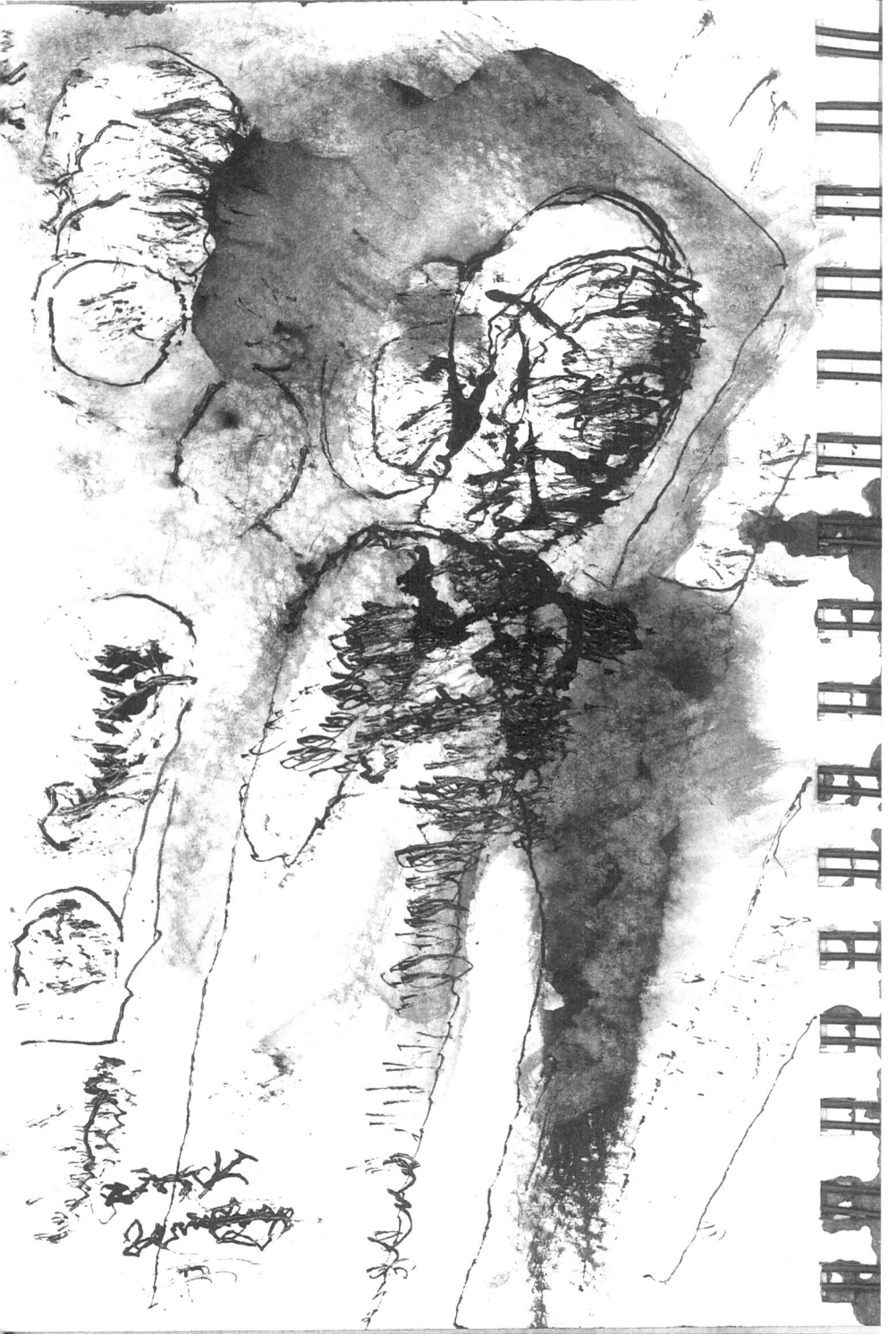

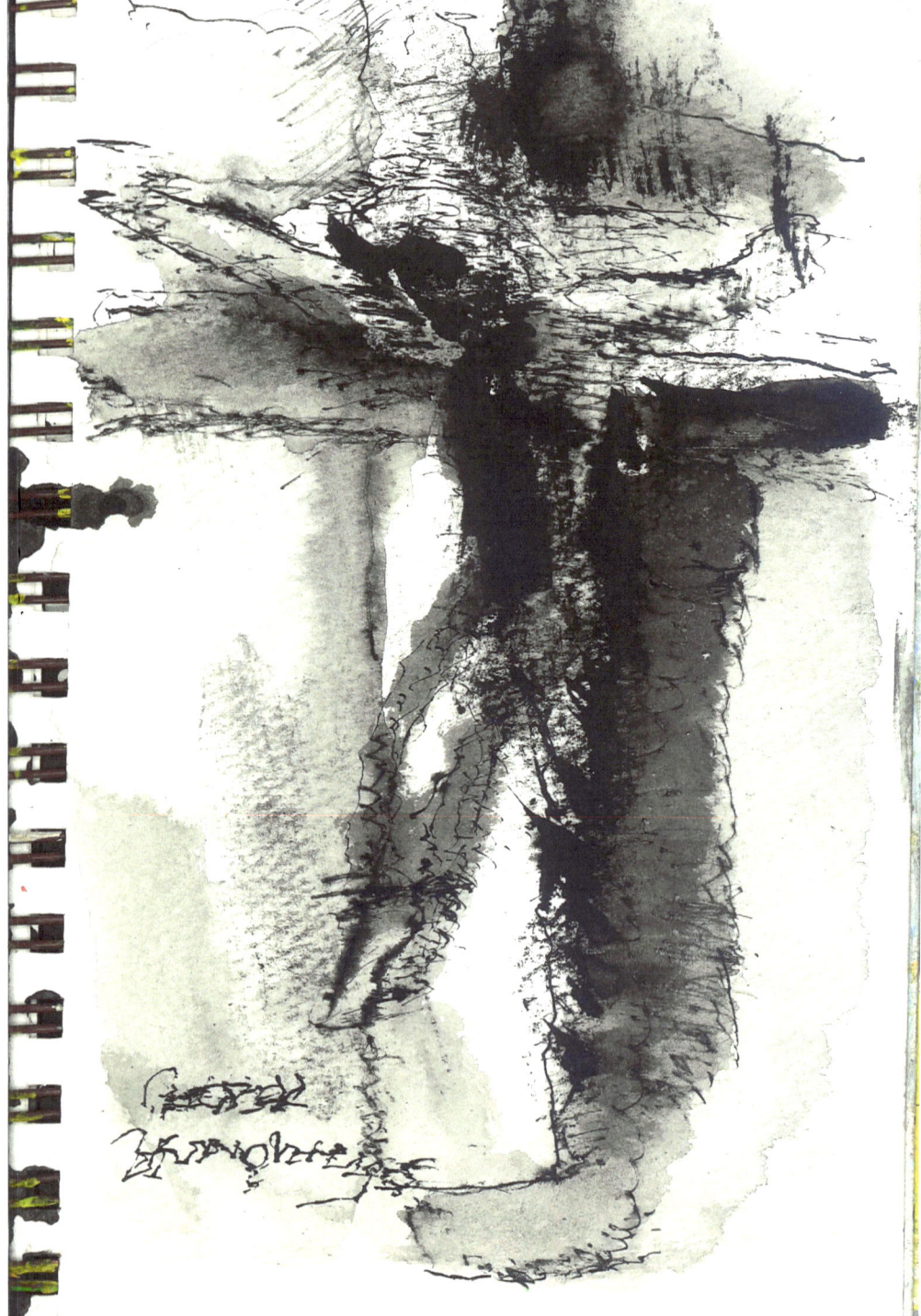

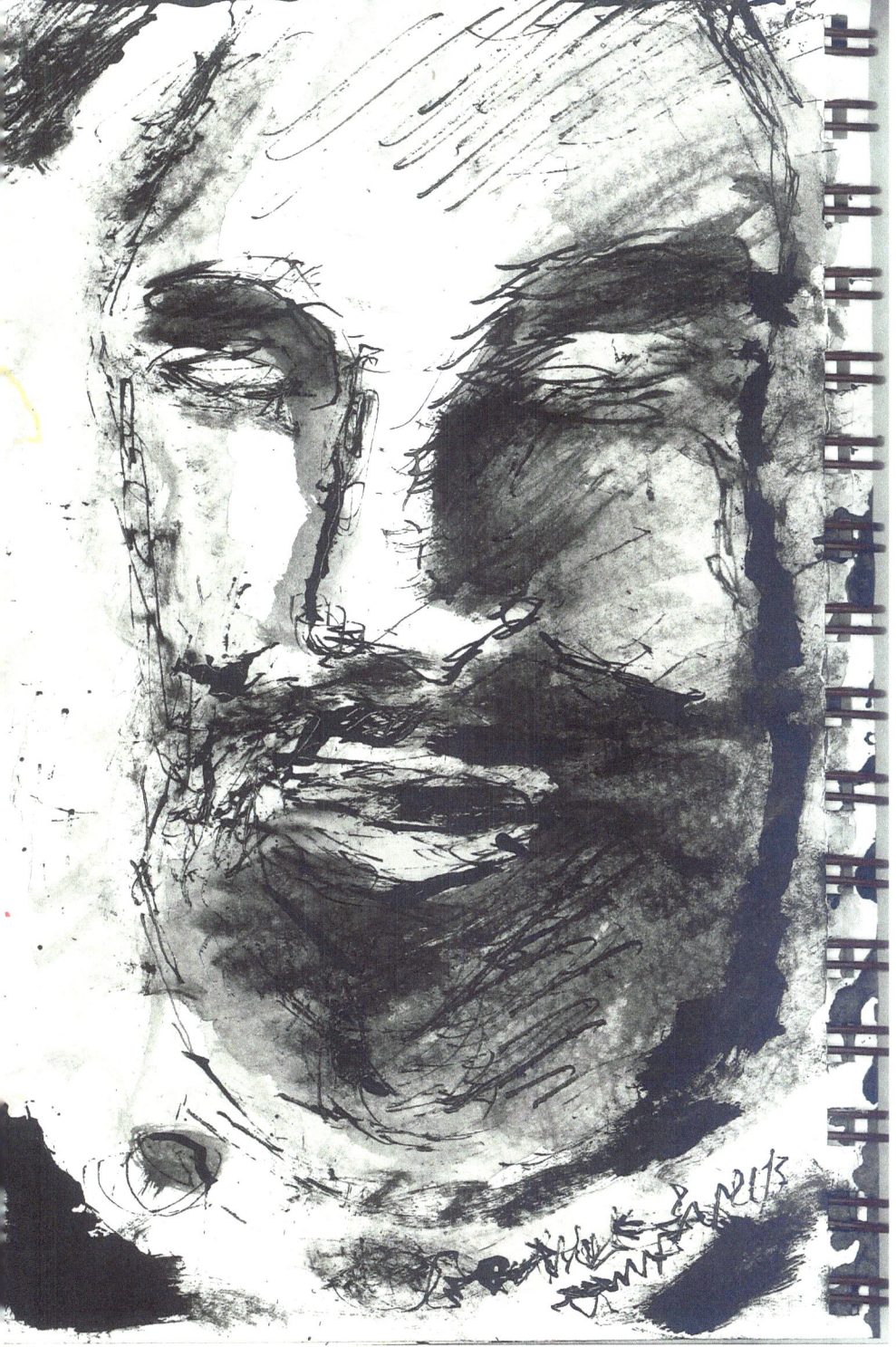

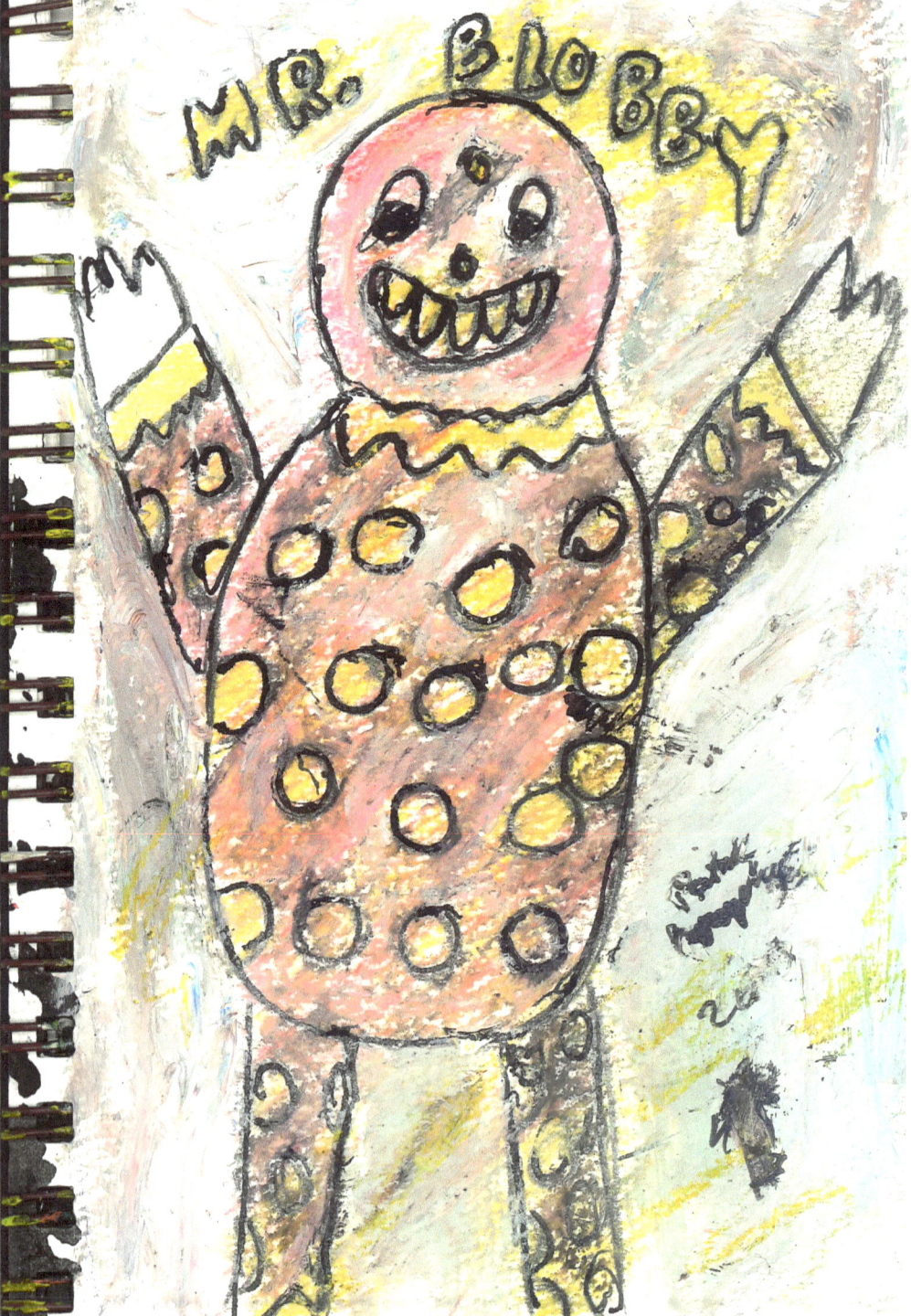

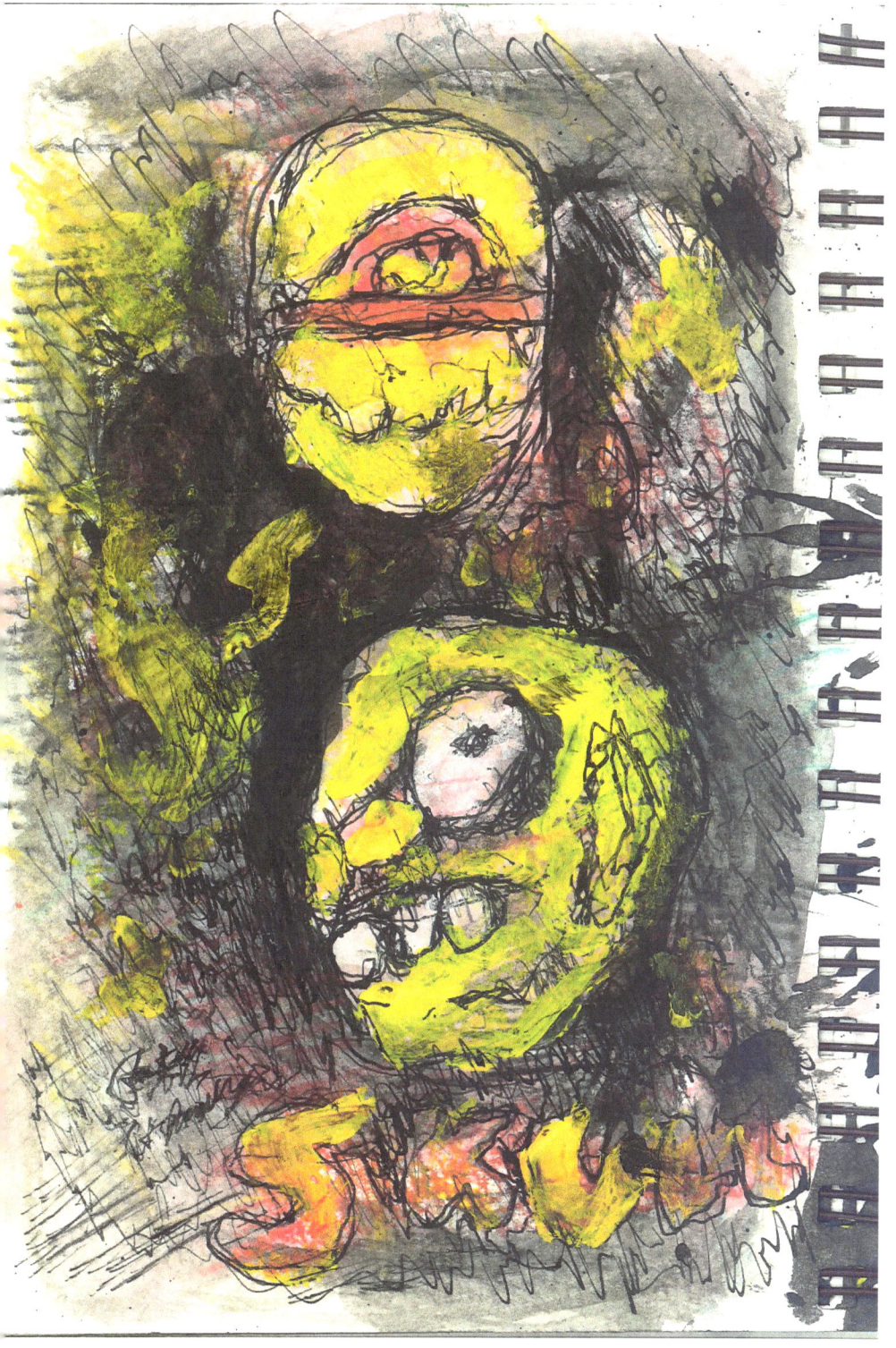

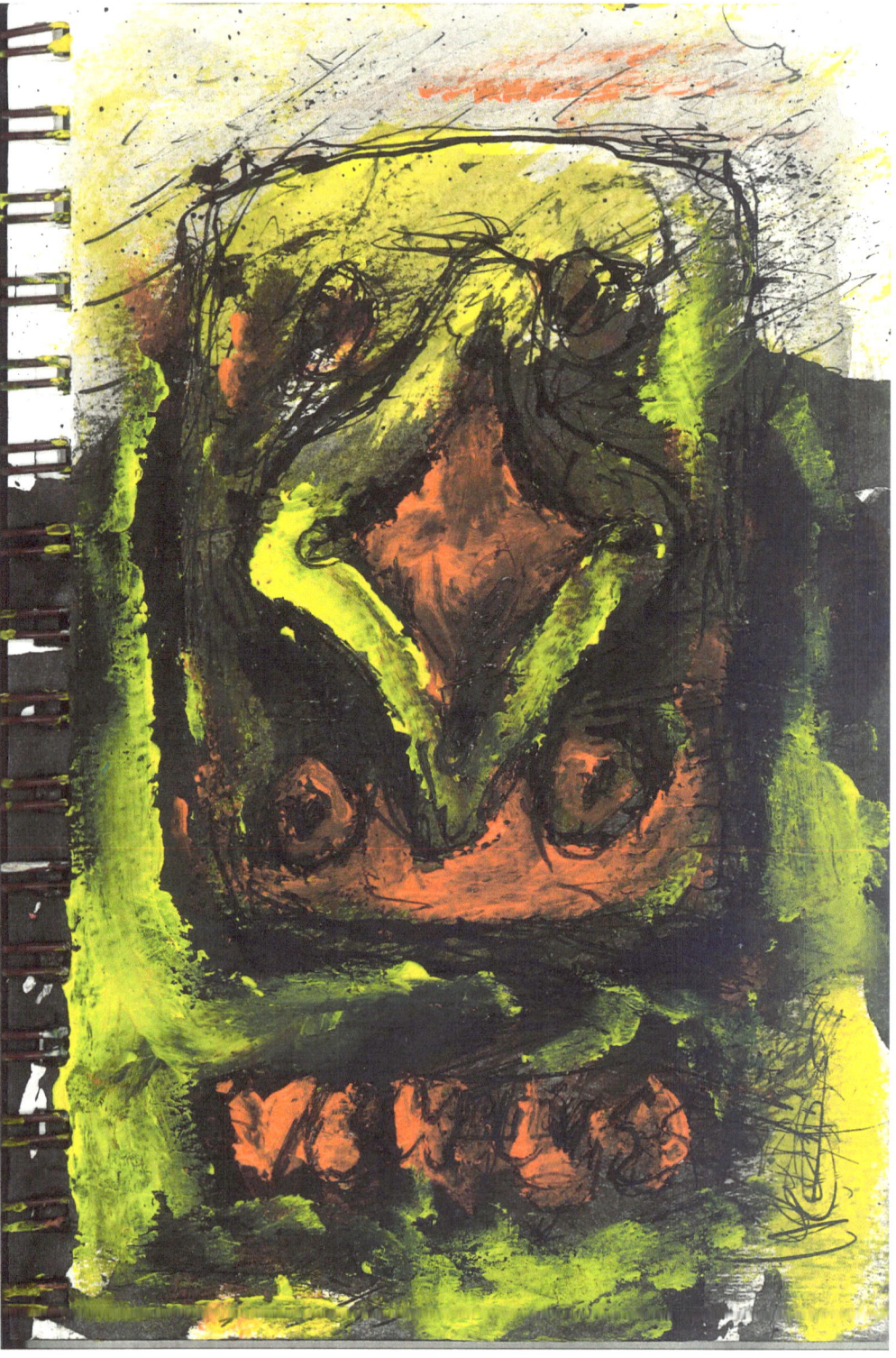

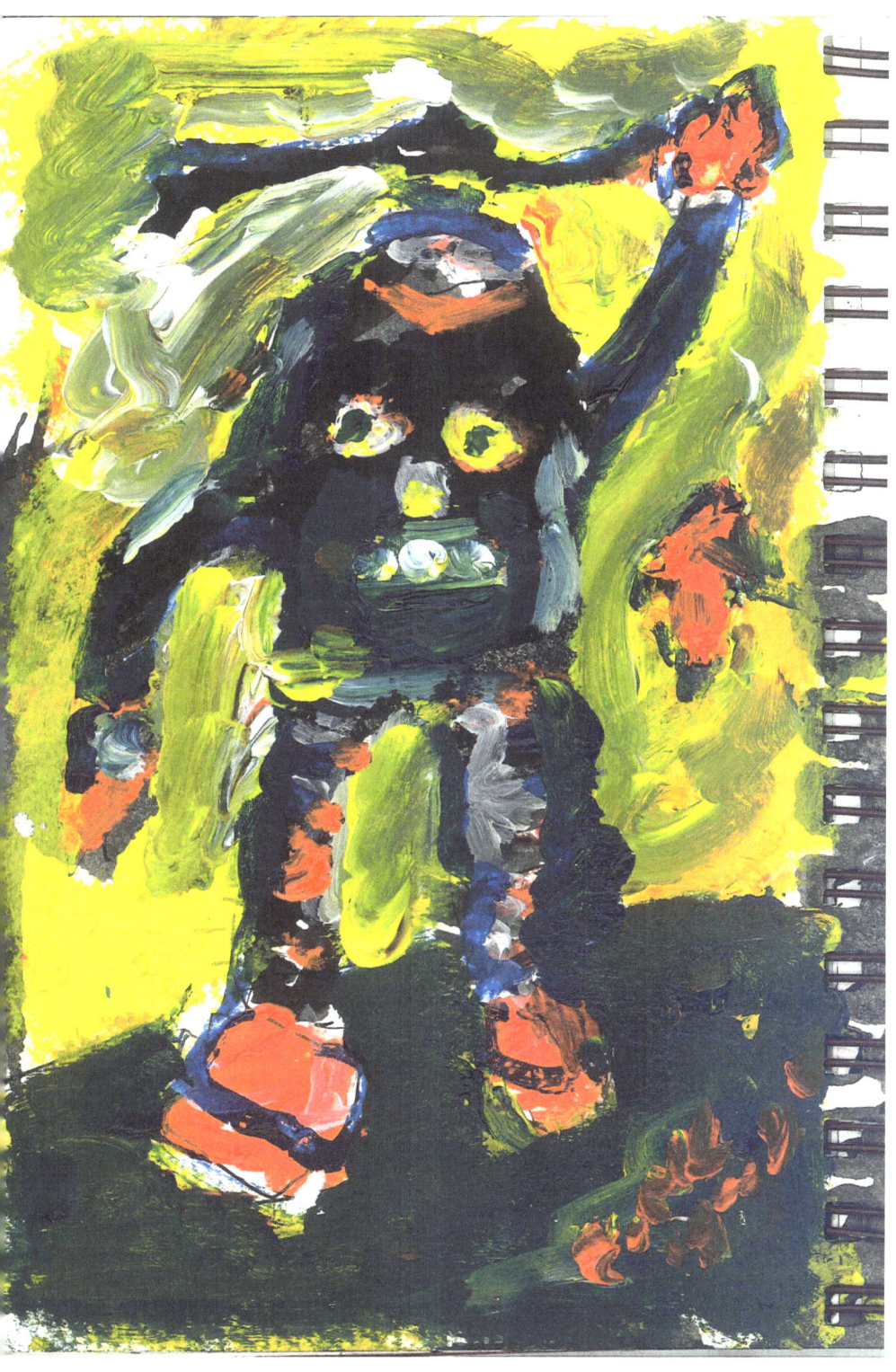

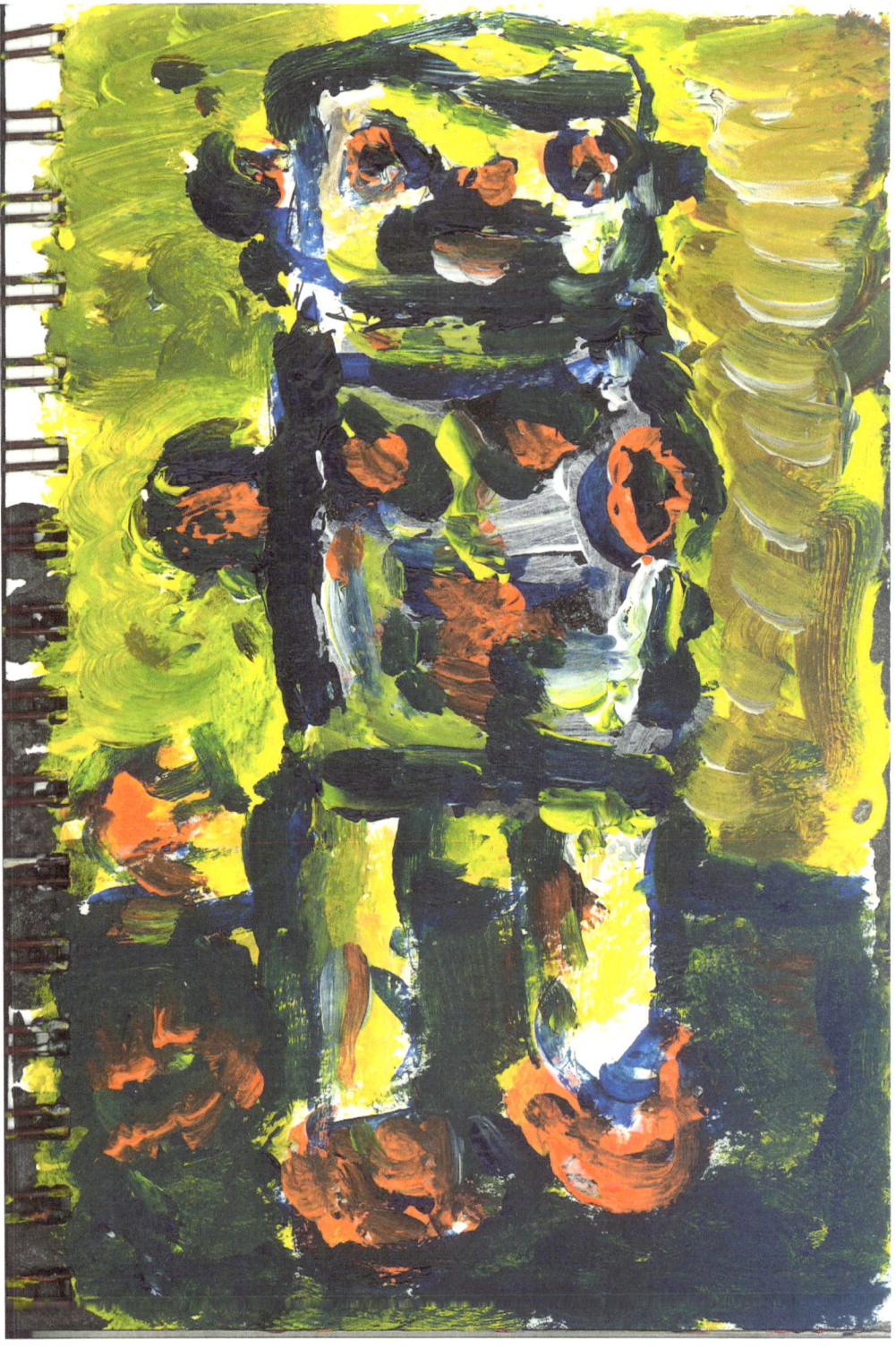

www.ingramcontent.com/pod-product-compliance
Lightning Source LLC
Chambersburg PA
CBHW040816200526

45159CB00024B/3005